INSTANT WALL ART:
BUTTERFLY
BOTANICAL PRINTS

45 READY-TO-FRAME VINTAGE
ILLUSTRATIONS FOR YOUR HOME DÉCOR

Adams Media
New York London Toronto Sydney New Delhi

Adams Media
An Imprint of Simon & Schuster, Inc.
57 Littlefield Street
Avon, Massachusetts 02322

First Adams Media trade paperback edition NOVEMBER 2017

ADAMS MEDIA and colophon are trademarks of Simon and Schuster.

For information about special discounts for bulk purchases, please contact Simon & Schuster Special Sales at 1-866-506-1949 or business@simonandschuster.com.

The Simon & Schuster Speakers Bureau can bring authors to your live event. For more information or to book an event contact the Simon & Schuster Speakers Bureau at 1-866-248-3049 or visit our website at www.simonspeakers.com.

Manufactured in the United States of America

10 9 8 7 6 5 4 3 2

ISBN 978-1-5072-0528-0

Contains material adapted from the following title published by Adams Media, an Imprint of Simon & Schuster, Inc.: *The Art of Nature Coloring Book* by Adams Media, copyright © 2013, ISBN 978-1-4405-7060-5.

INTRODUCTION

Today, beautifully colored nature prints are showing up everywhere you look—from popular design magazines and websites to the walls of your friends' living rooms and kitchens. And now, instead of having to choose between one or two expensive prints, you can choose from the forty-five beautiful illustrations found within the pages of *Instant Wall Art: Butterfly Botanical Prints* to personalize your own walls!

Extraordinarily popular in the eighteenth and nineteenth centuries, these types of prints were first drawn and hand-colored by botanists, who used the lovely pastel shades of watercolors to capture the scientific details of the flora and insects they studied. Now, with images ranging from the graceful swallowtail butterfly to the elegant purple emperor butterfly to the delicate monarch butterfly, you're sure to find something in this book that speaks to your design aesthetic. These nature prints measure 8" x 10" and will fit in a standard mat and frame once removed from the book at the perforated edge. So choose the prints you love, hang them on your walls, and enjoy the elegance of nature in your own home, year round!

THE
PRINTS

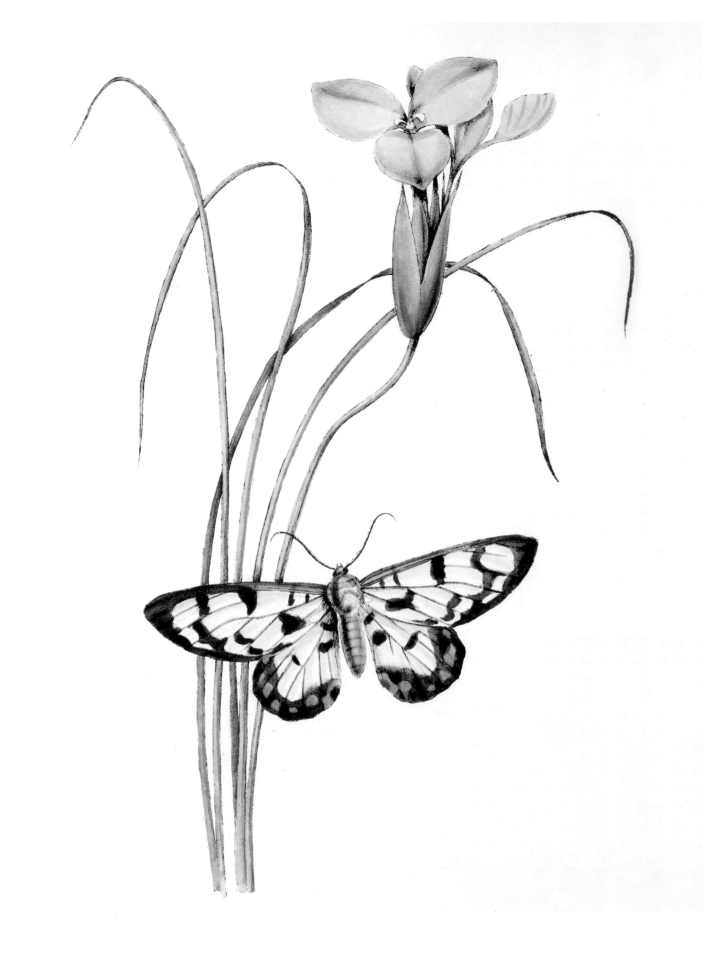

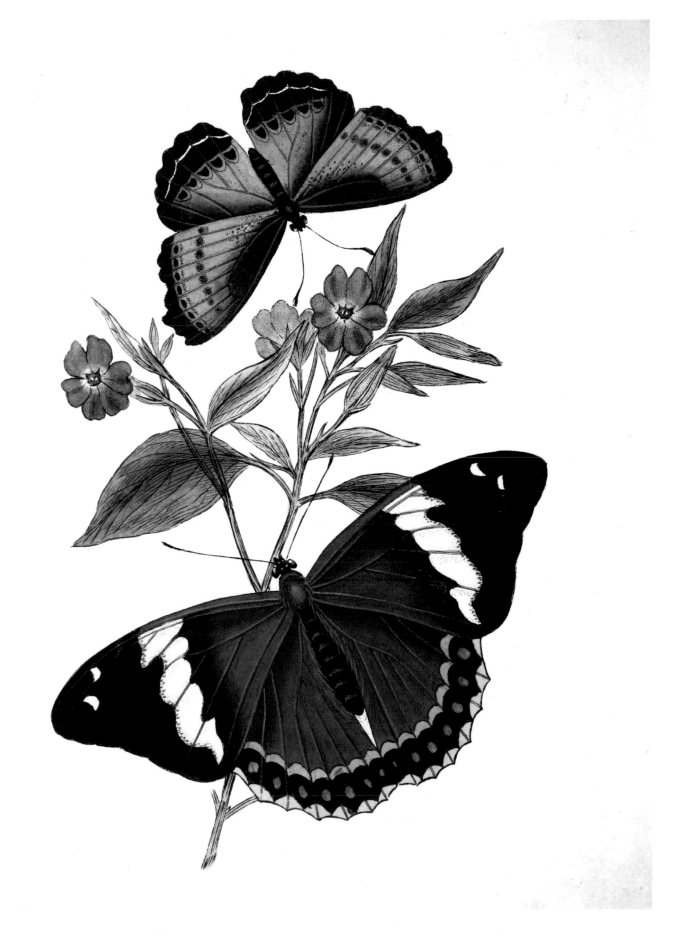

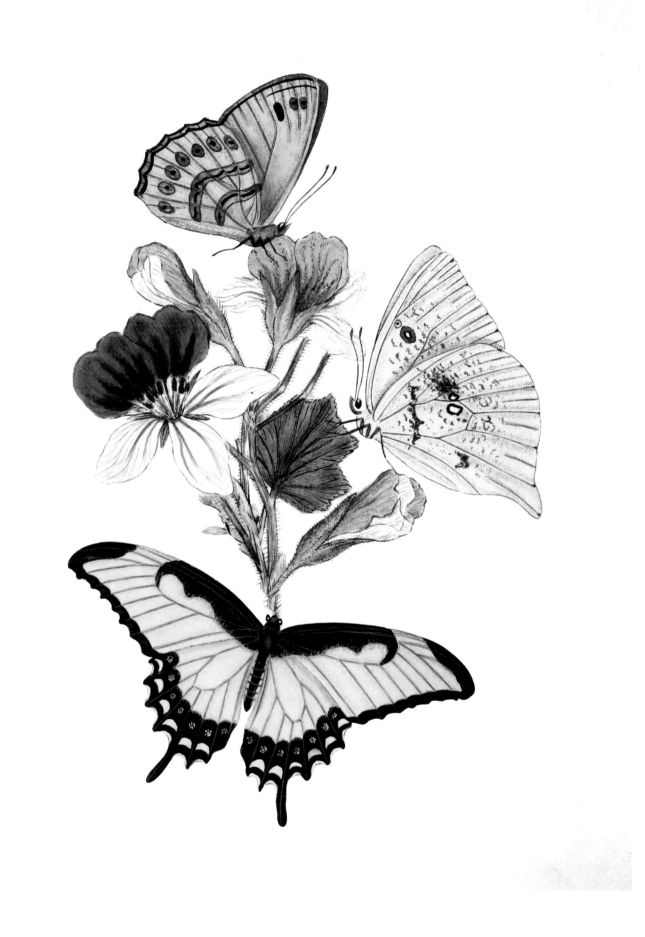

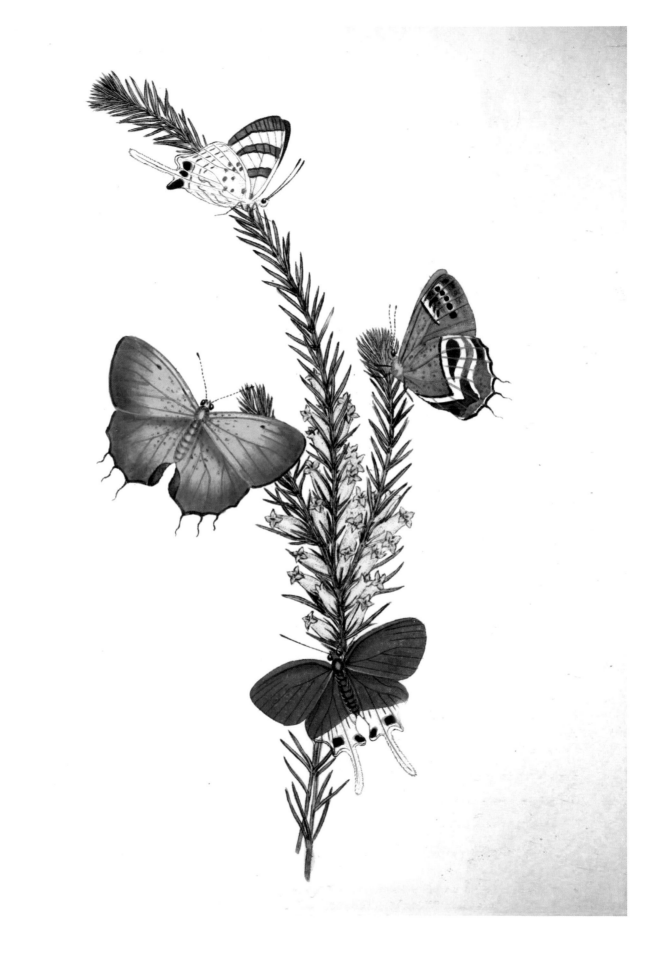

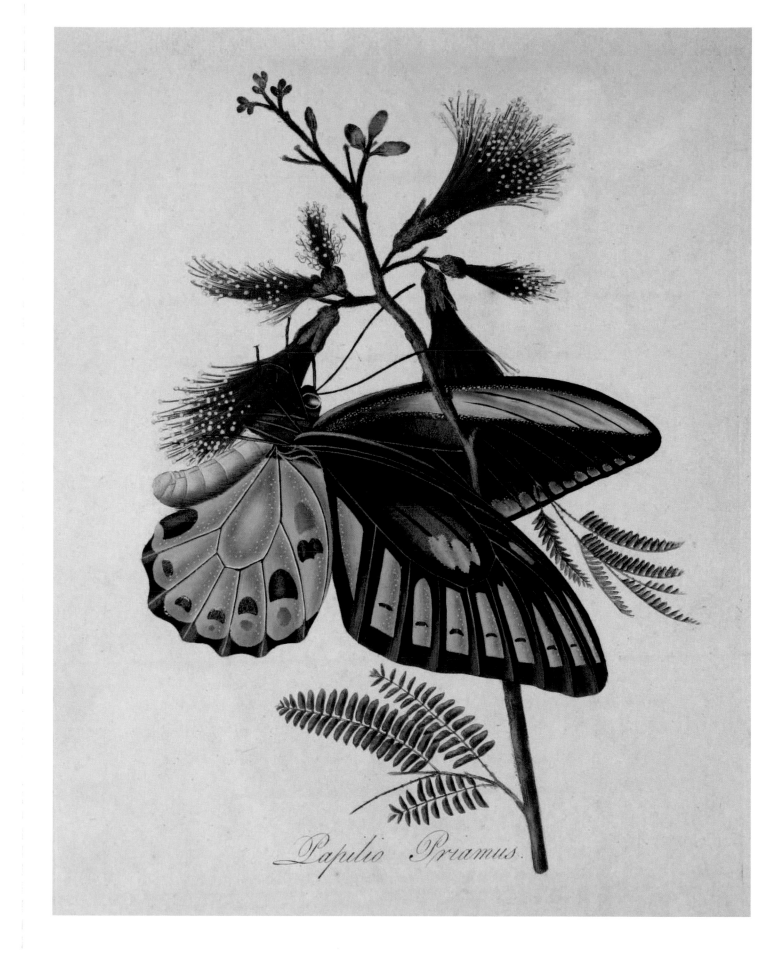

Papilio Priamus.

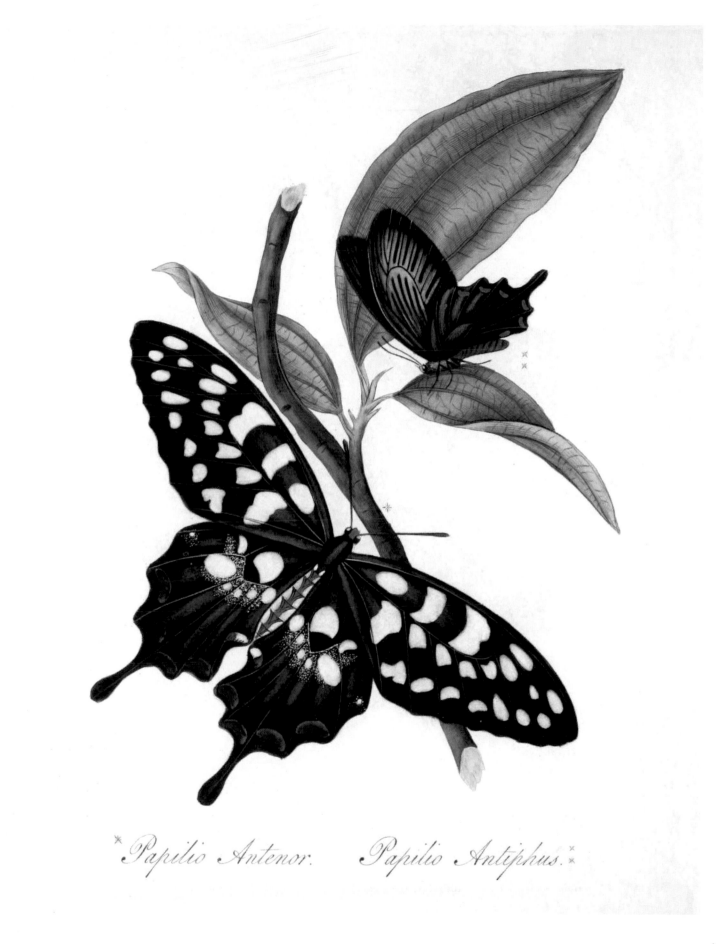

Papilio Antenor. Papilio Antiphus.

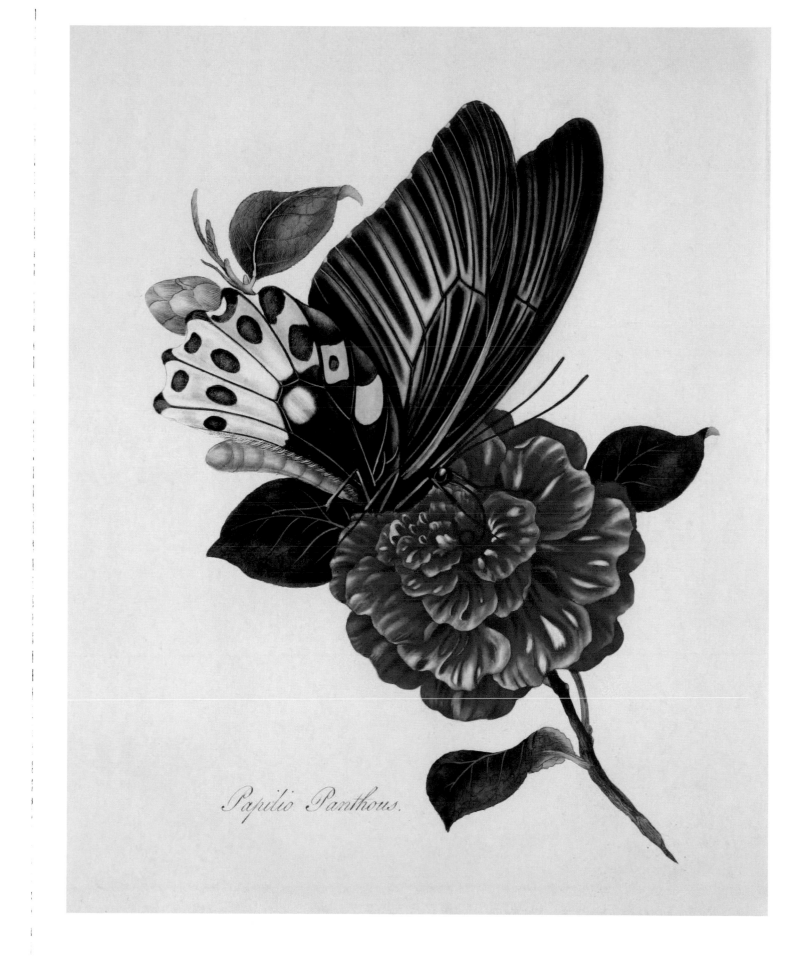

Papilio Panthous.

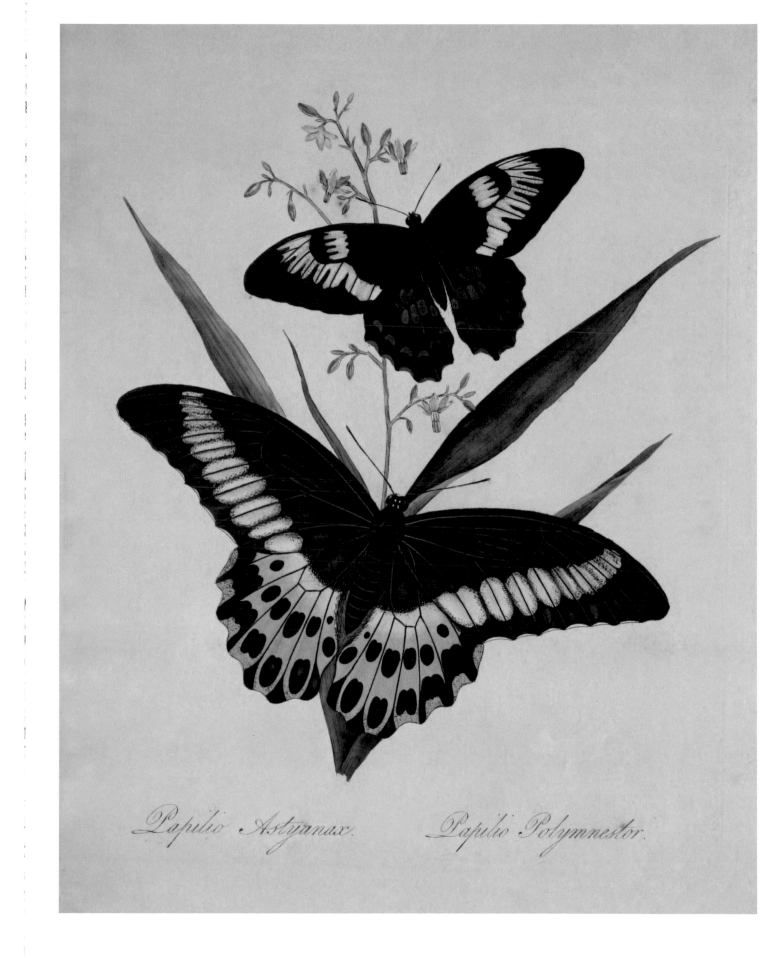

Papilio Astyanax. *Papilio Polymnestor.*

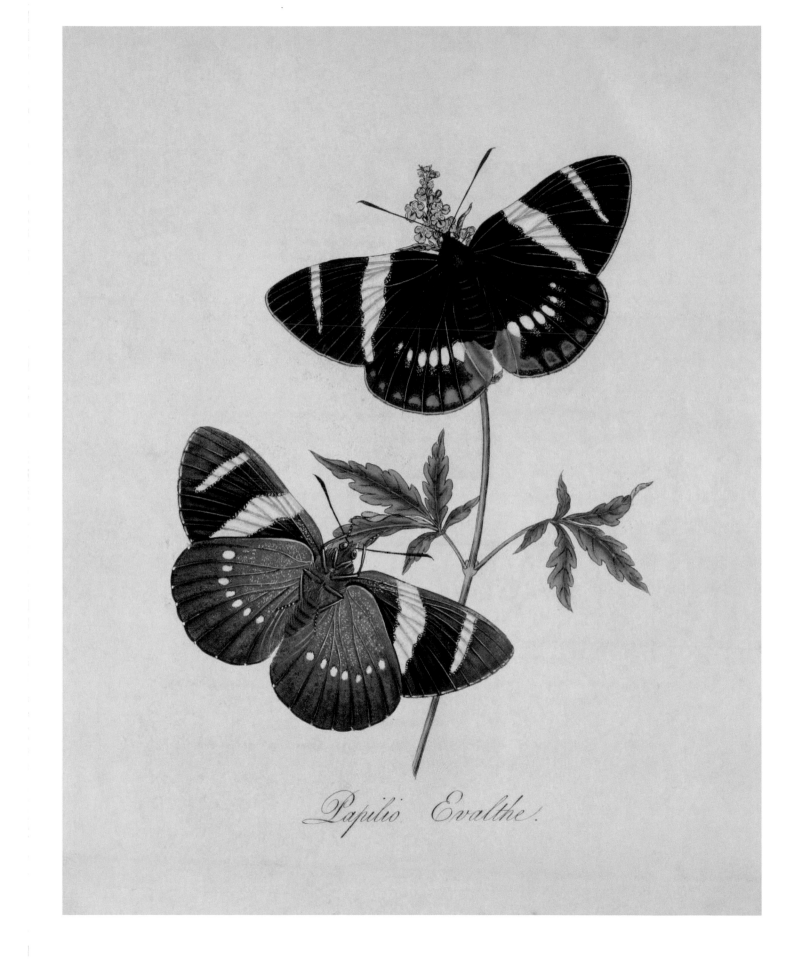

Papilio Evalthe.

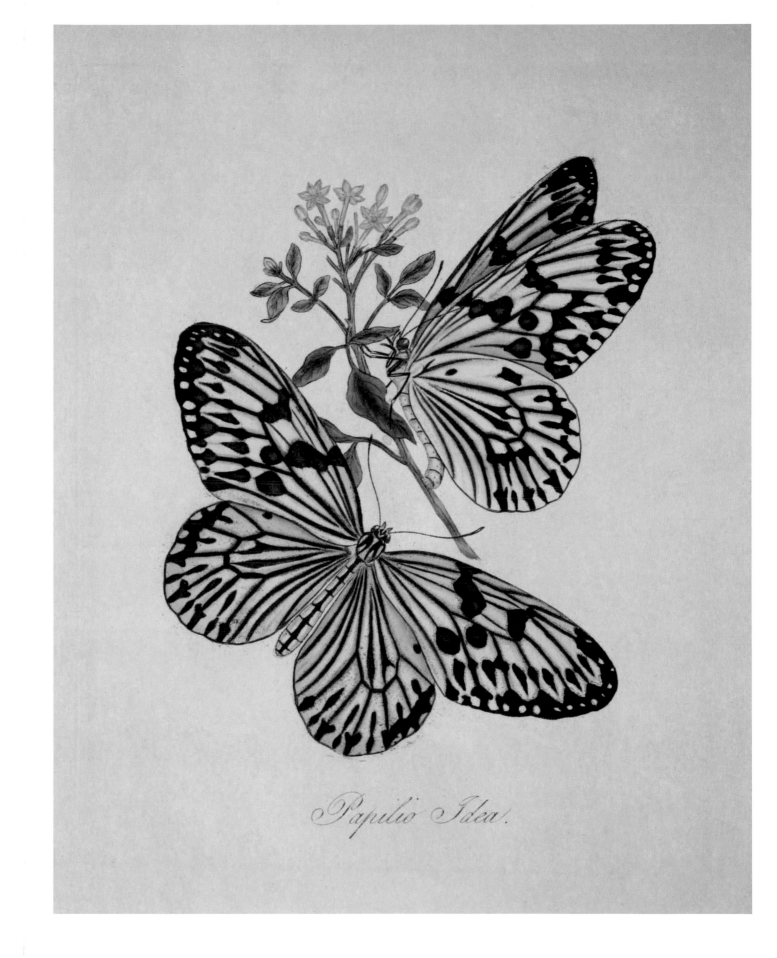

Papilio Idea.

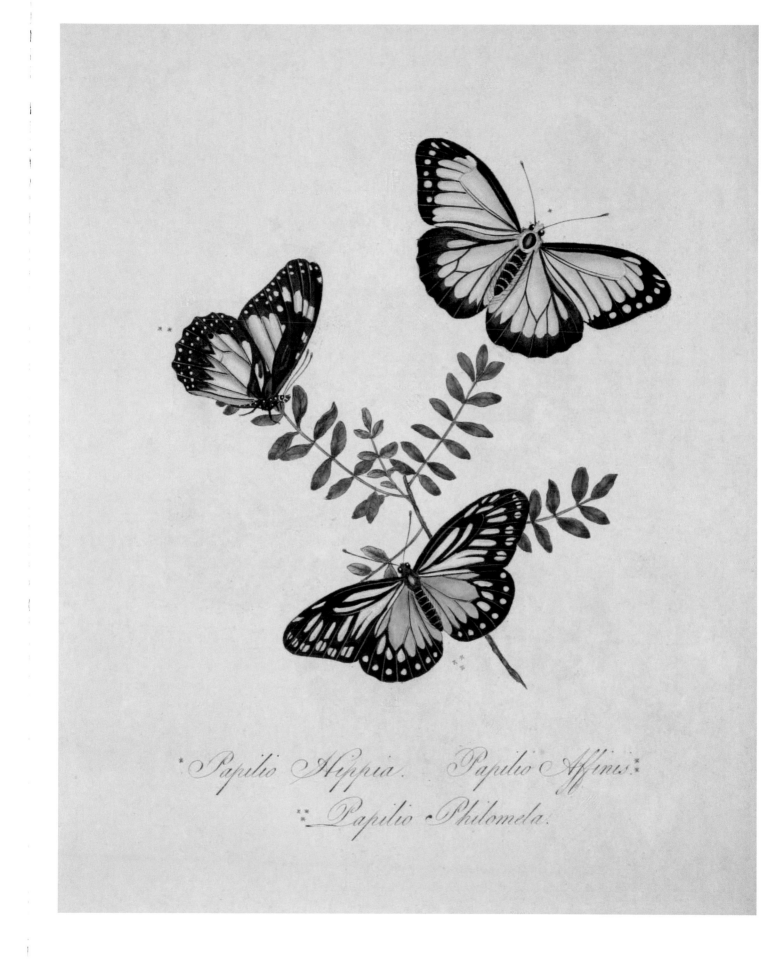

Papilio Hippia. Papilio Affinis.
Papilio Philomela.

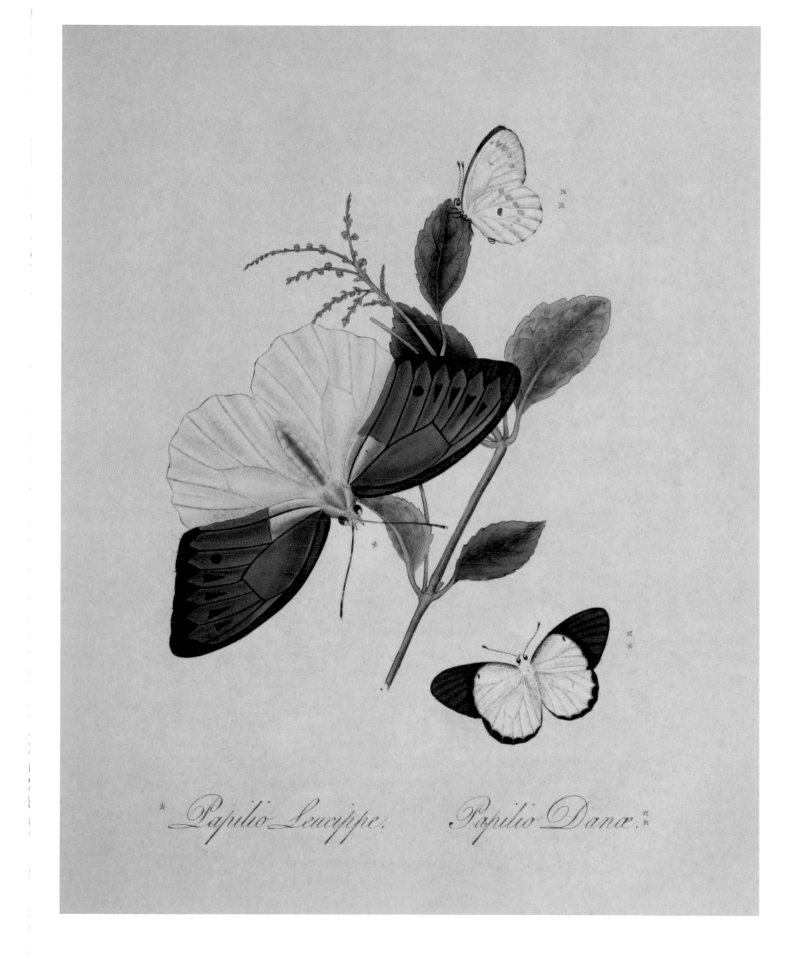

Papilio Leucippe. *Papilio Danæ.*

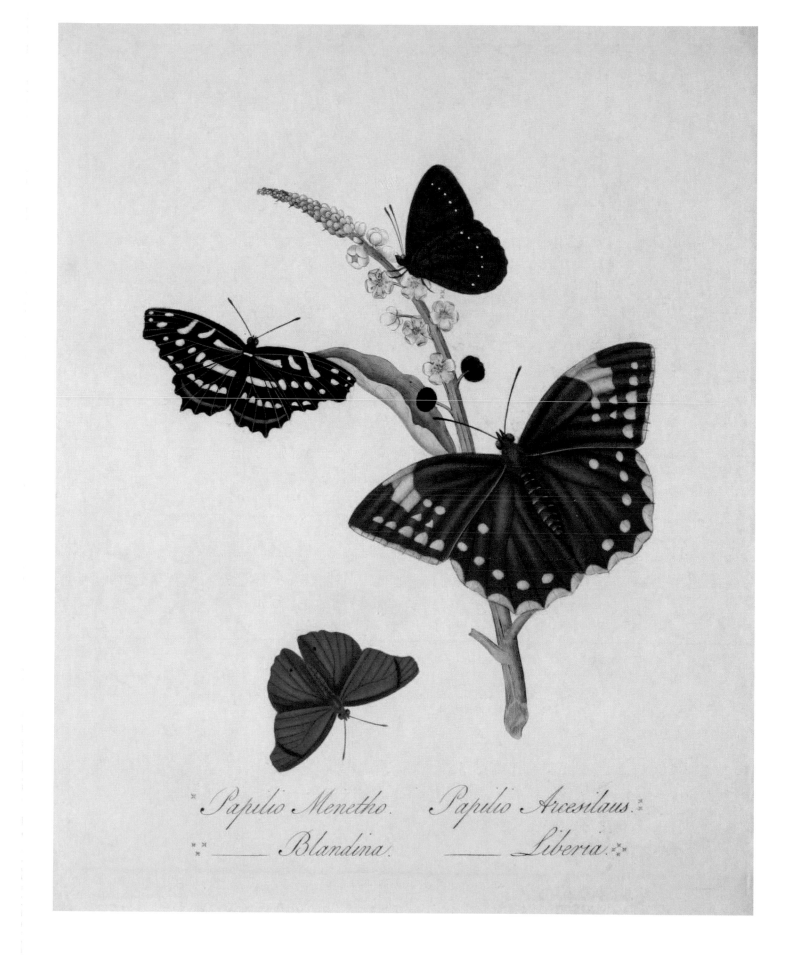

Papilio Menetho. *Papilio Arcesilaus.*
_____ *Blandina.* _____ *Liberia.*

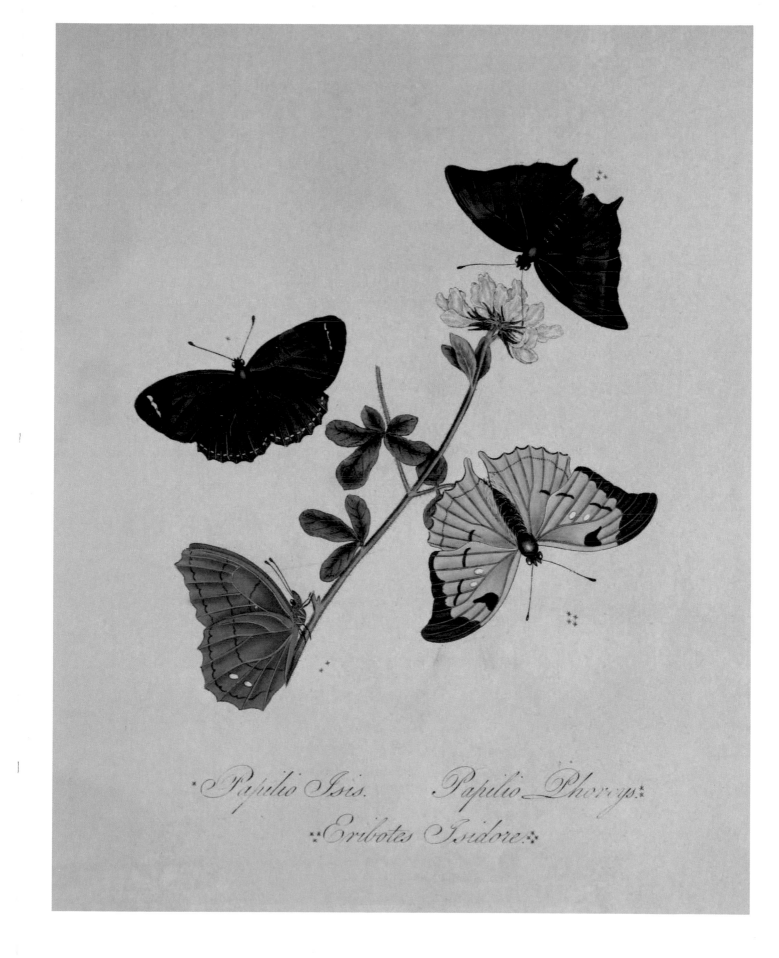

Papilio Isis. *Papilio Phorcys.*
Eribotes Isidore.

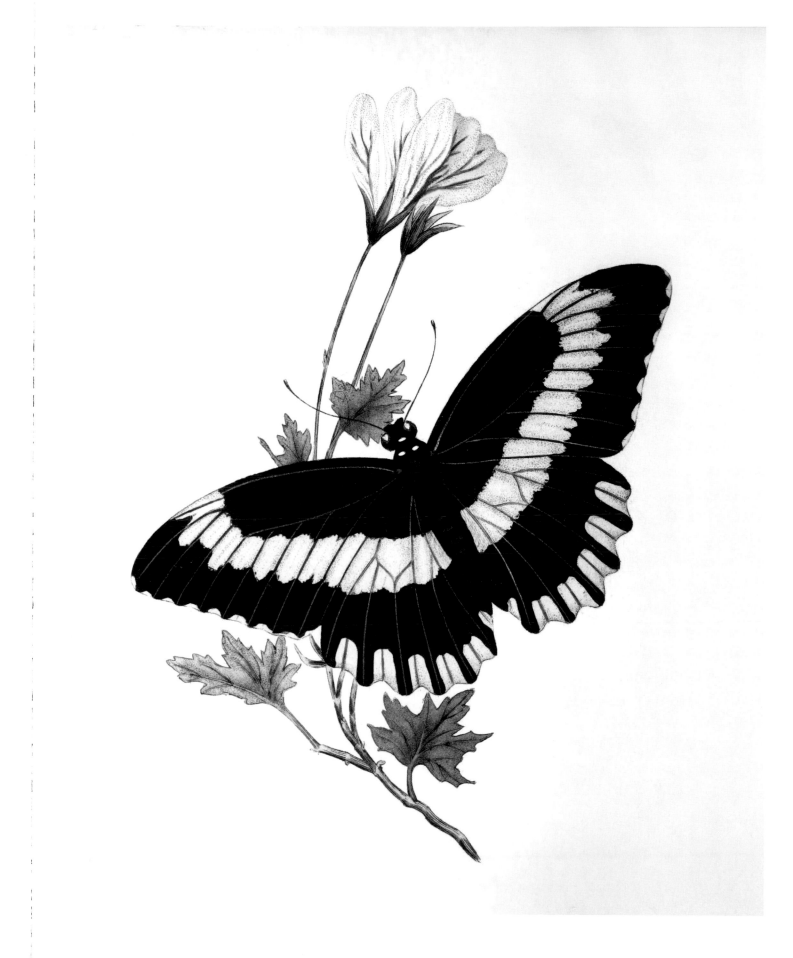

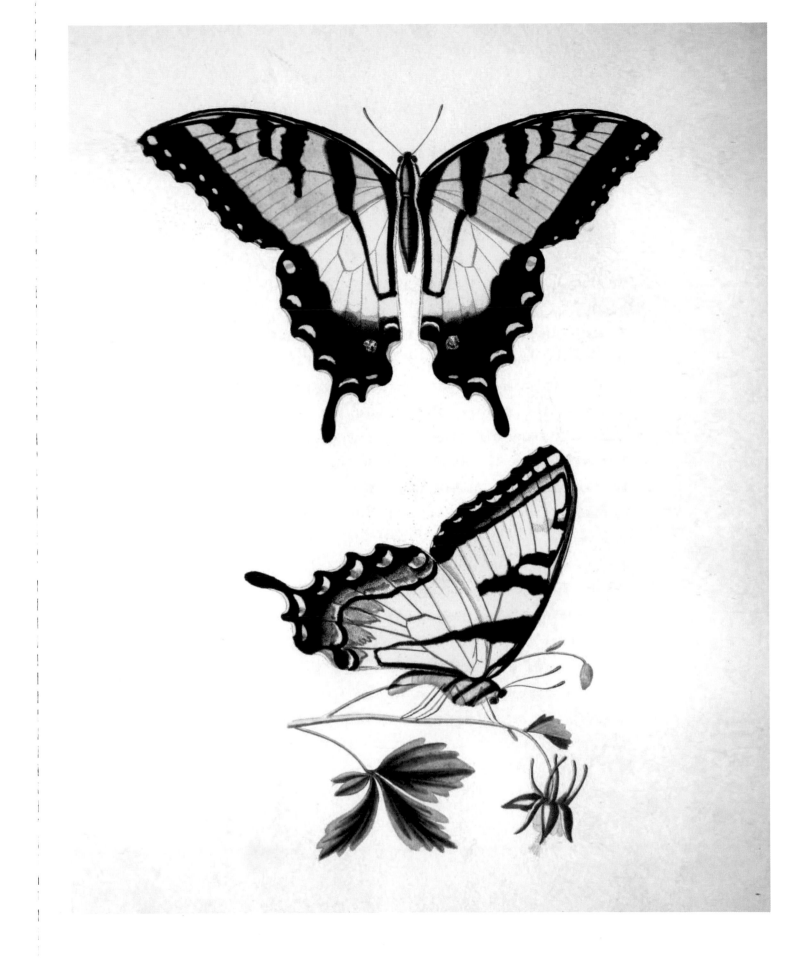

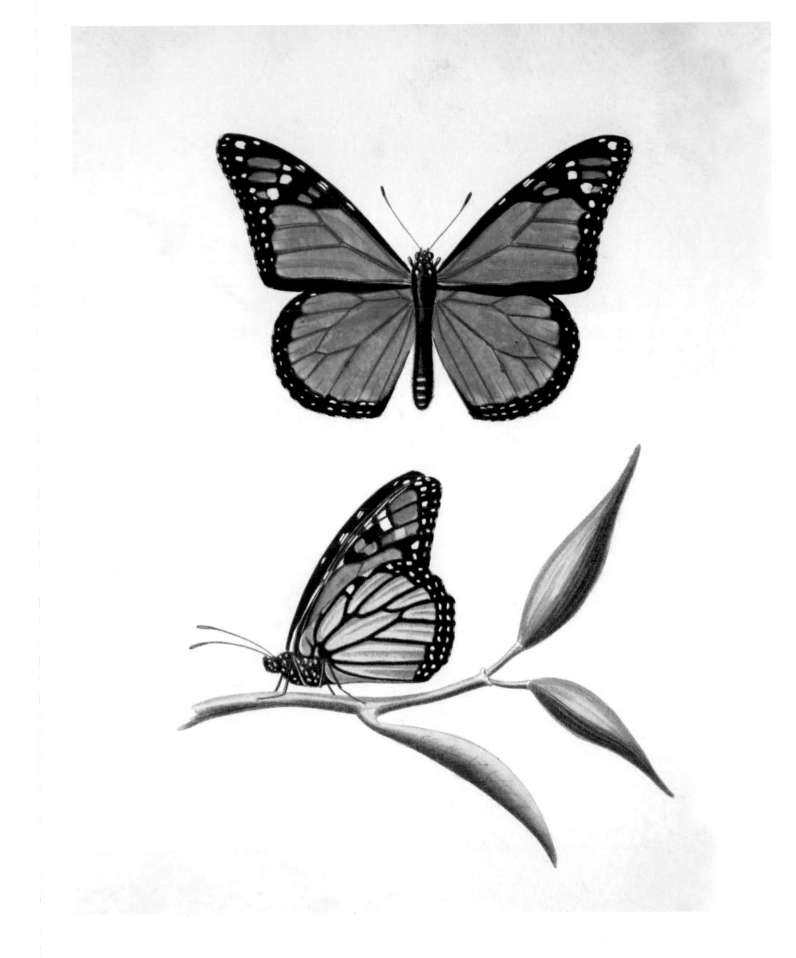

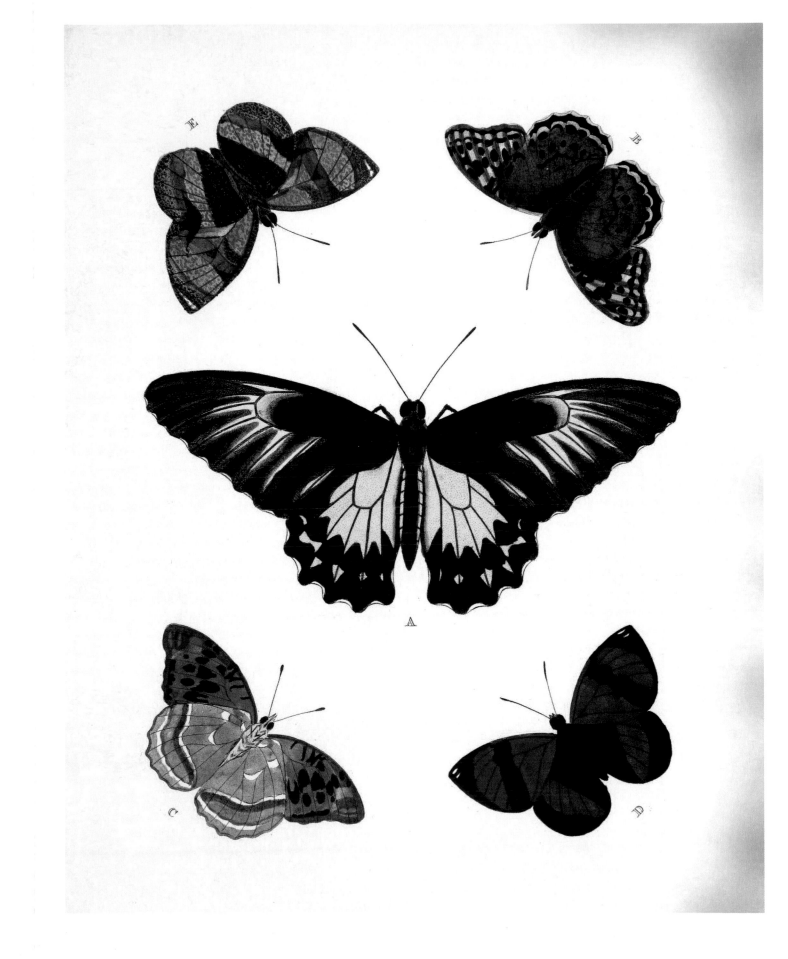

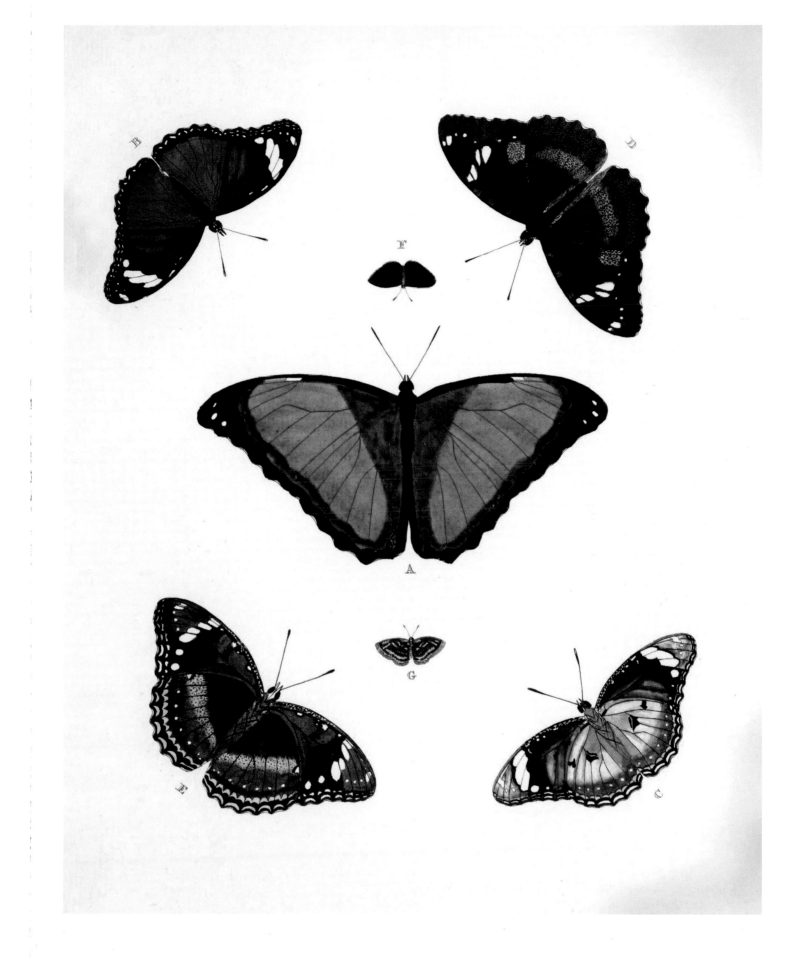

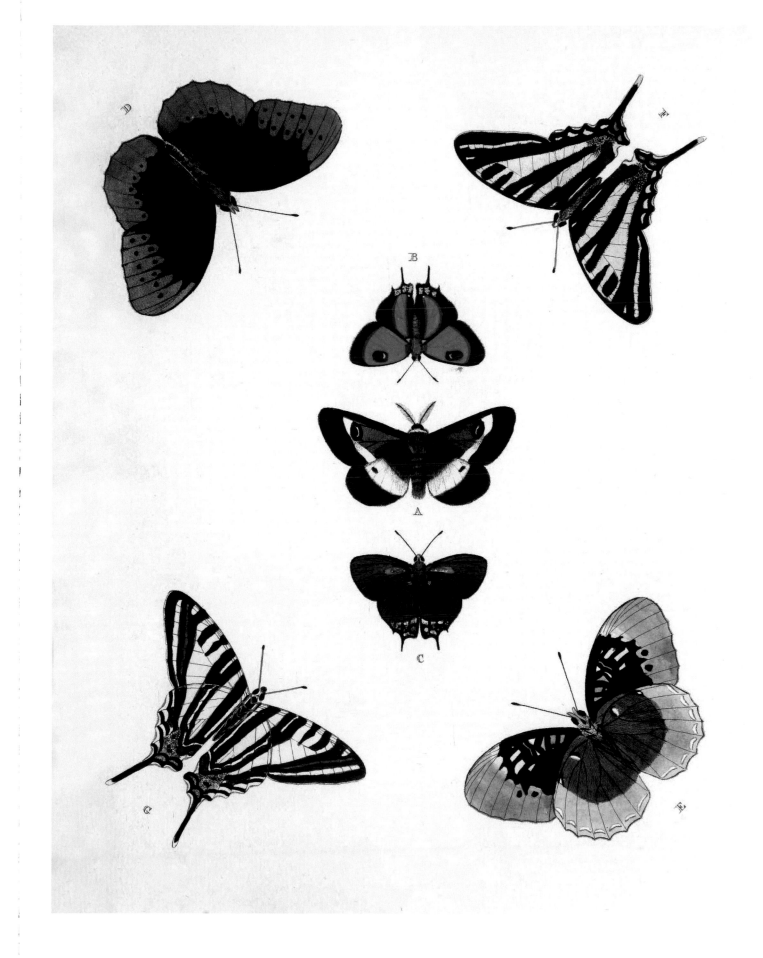

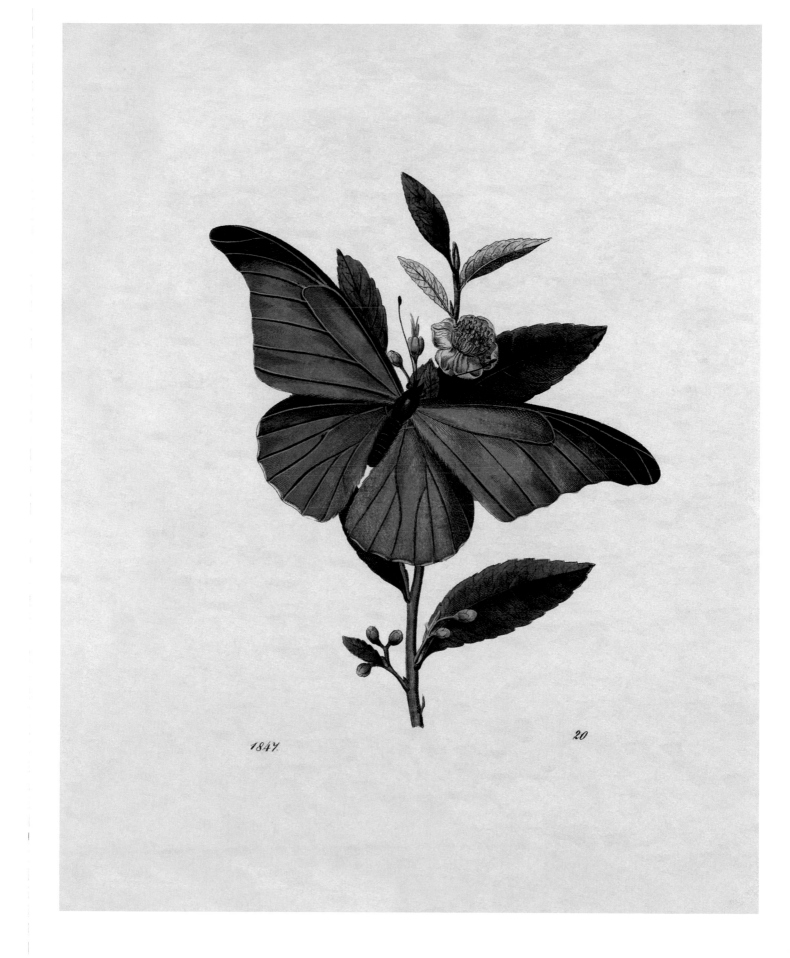

1847.

20

PLATE 4.

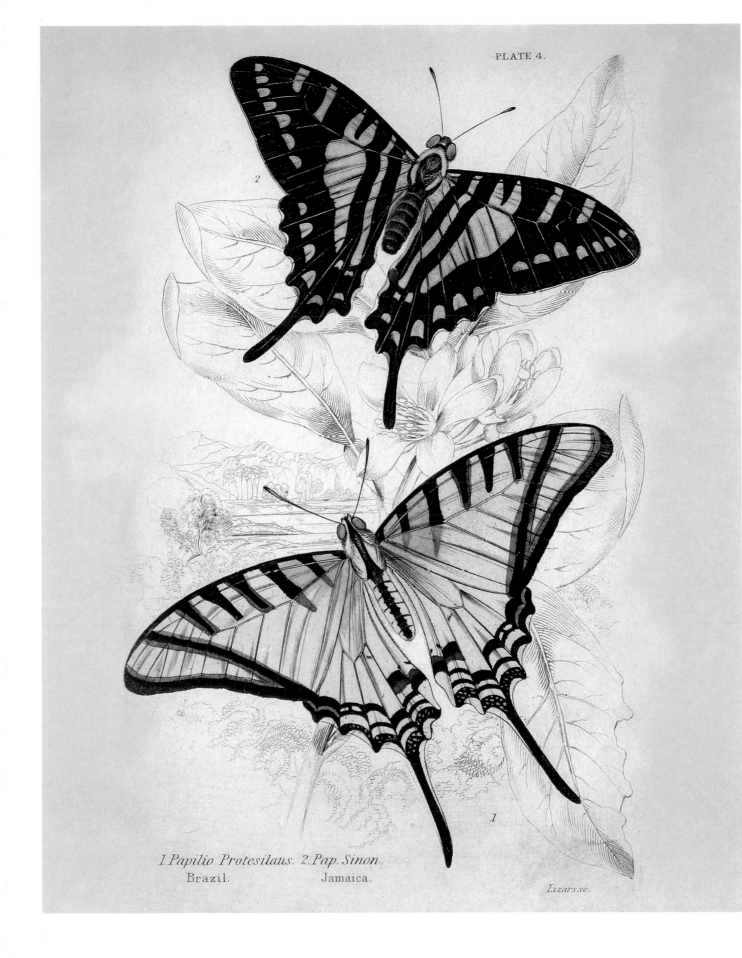

1.*Papilio Protesilaus.* 2.*Pap. Sinon.*
Brazil. Jamaica.

Lizars.sc.

ˌ

PLATE 11

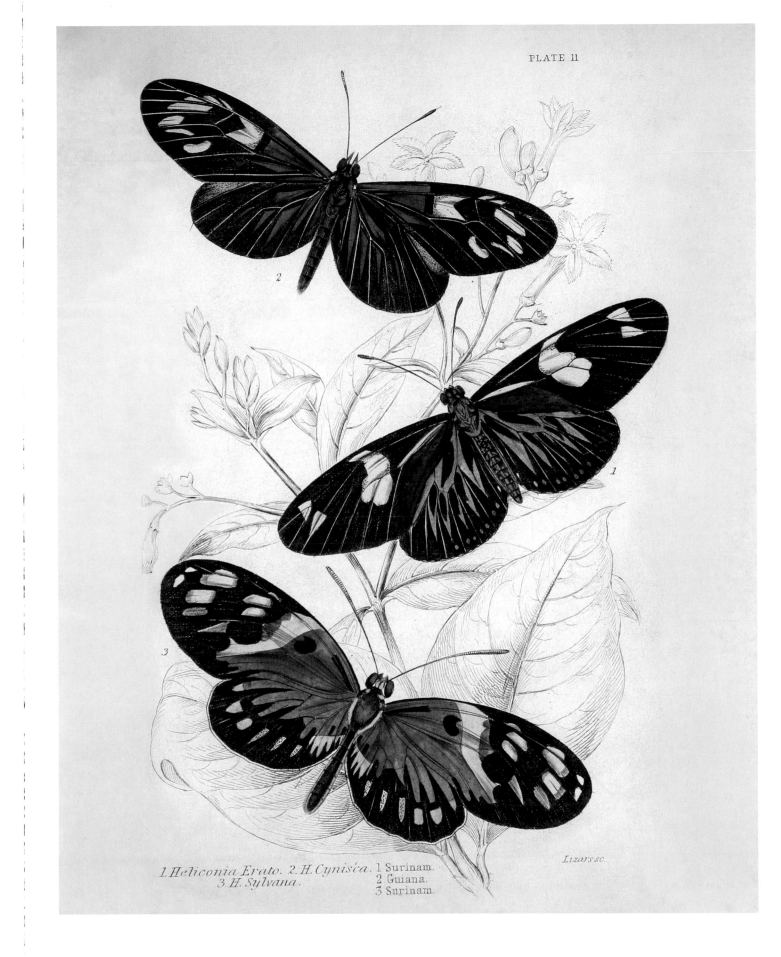

1.Heliconia Erato. 2.H.Cynisca. 1 Surinam.
 3.H. Sylvana. 2 Guiana.
 3 Surinam.

Lizars sc.

PLATE 18.

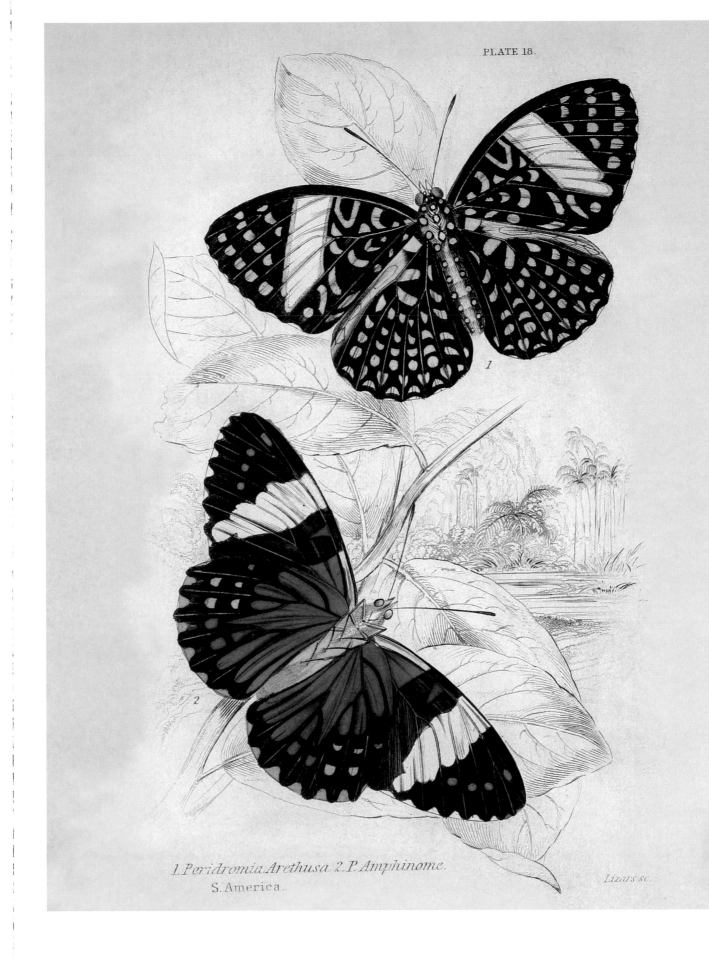

1. *Peridromia Arethusa* 2. *P. Amphinome*.
S. America.

Lizars sc.

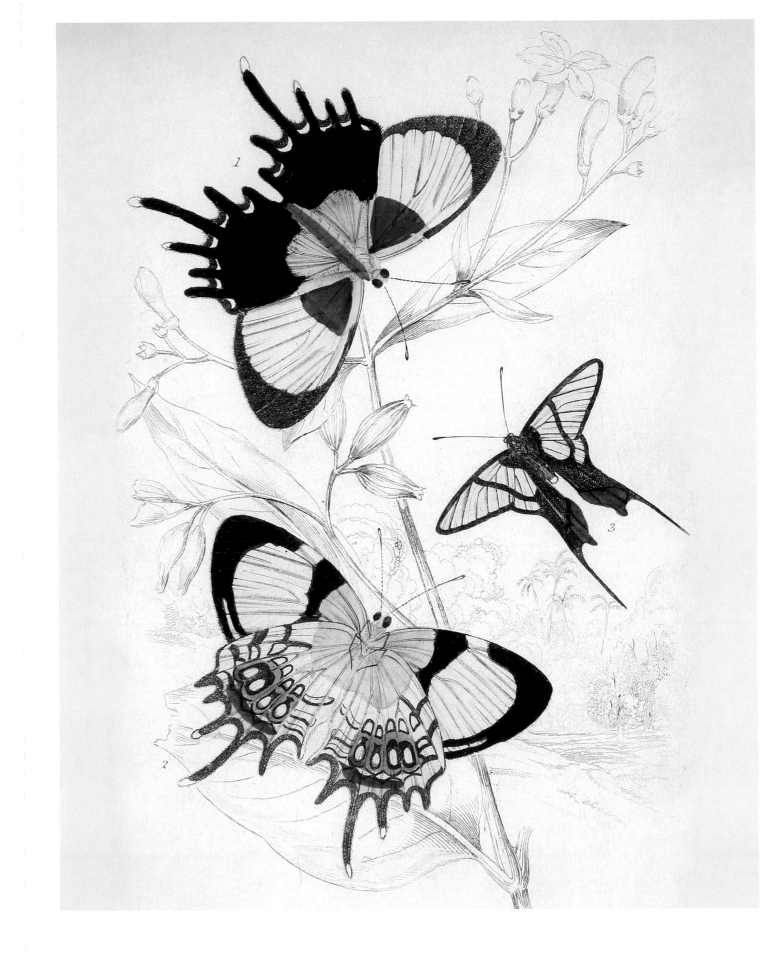

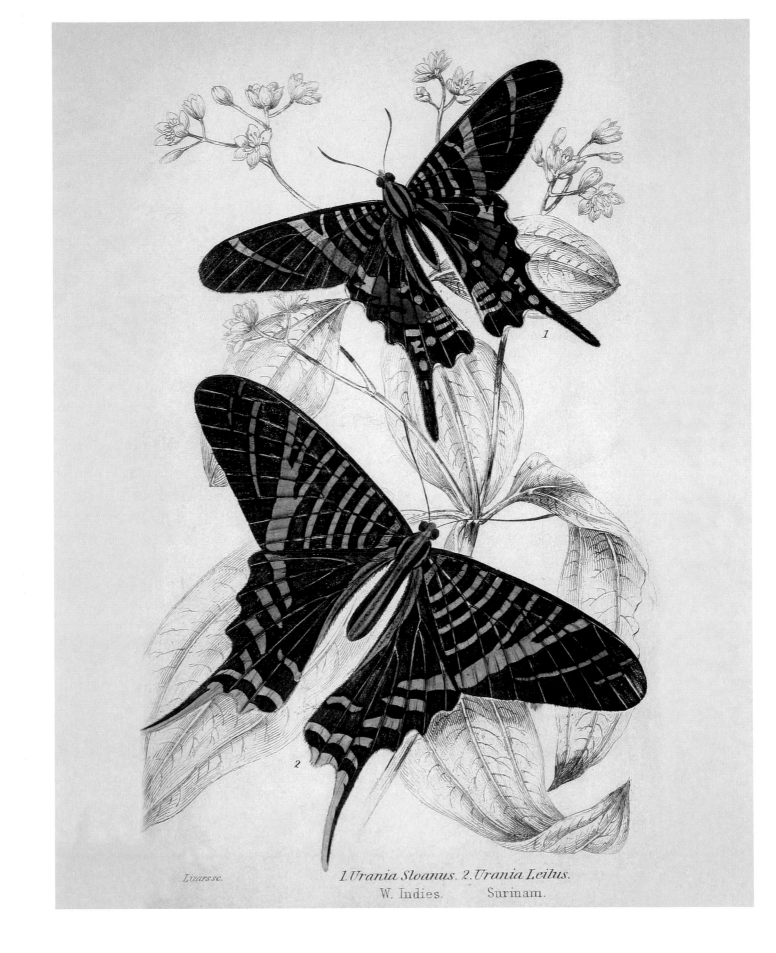

1. *Urania Sloanus.* 2. *Urania Leilus.*
W. Indies. Surinam.

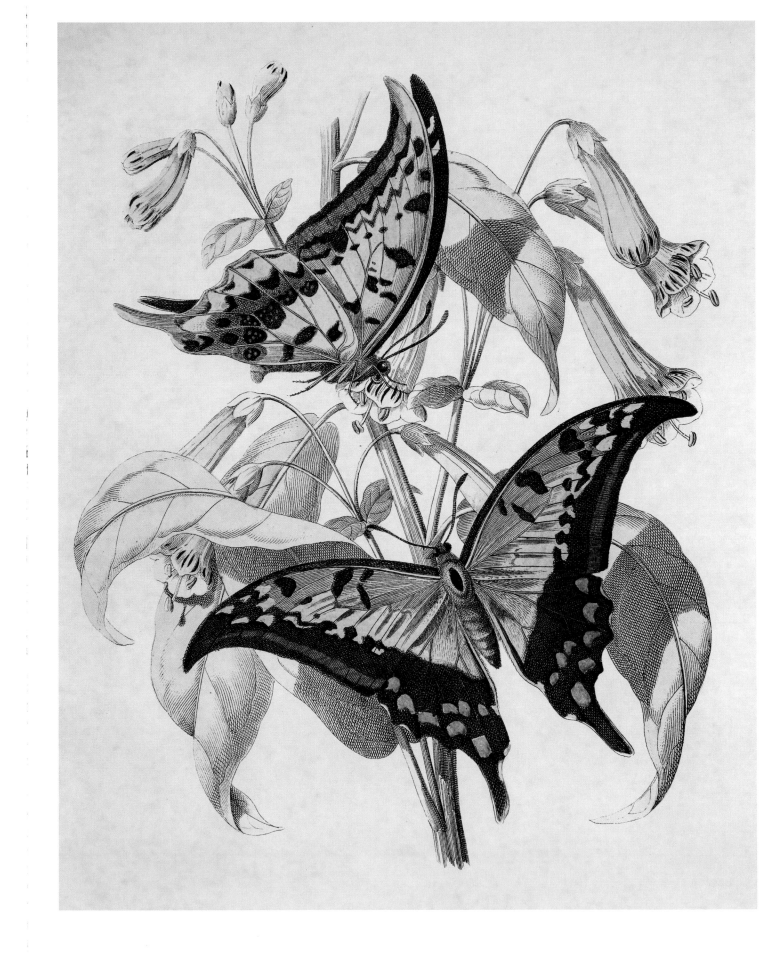

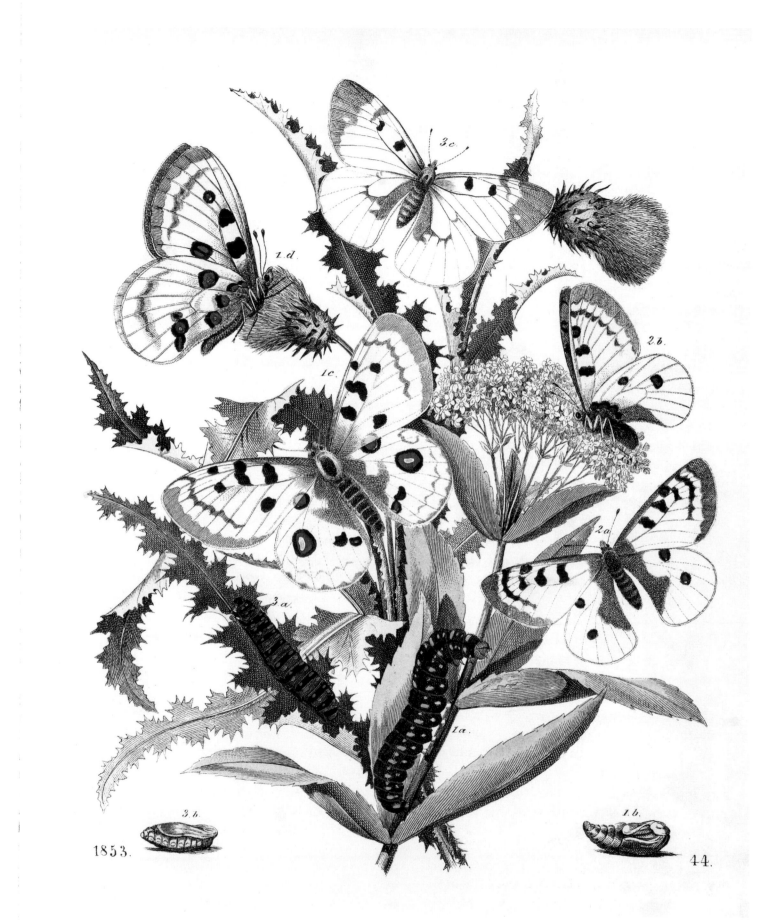

1853.

44.

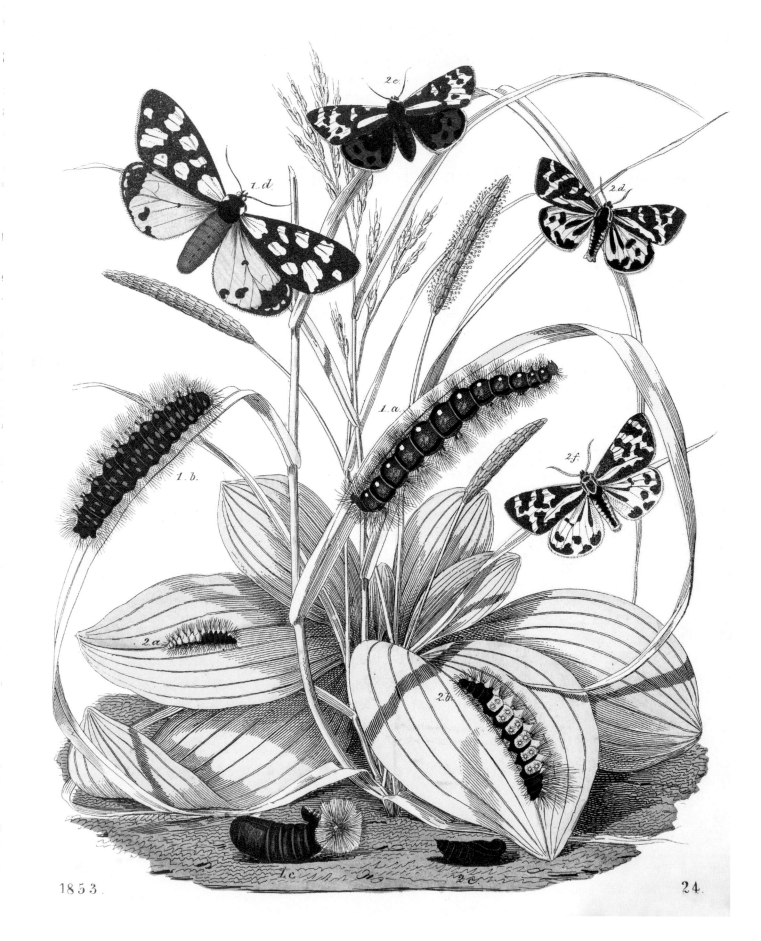

1853.

24.

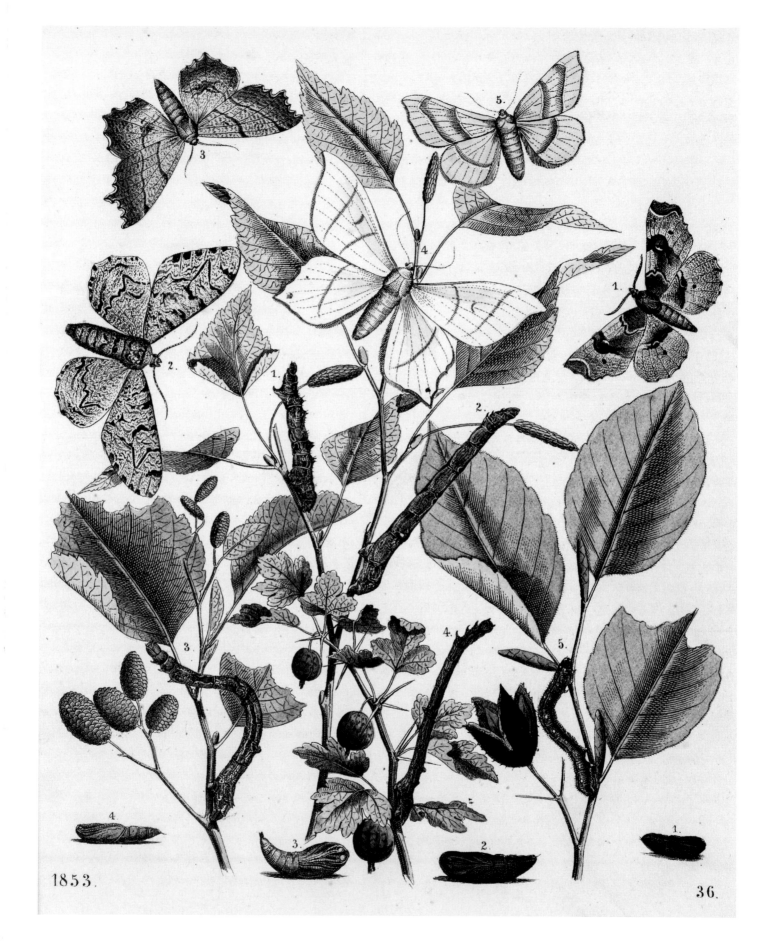

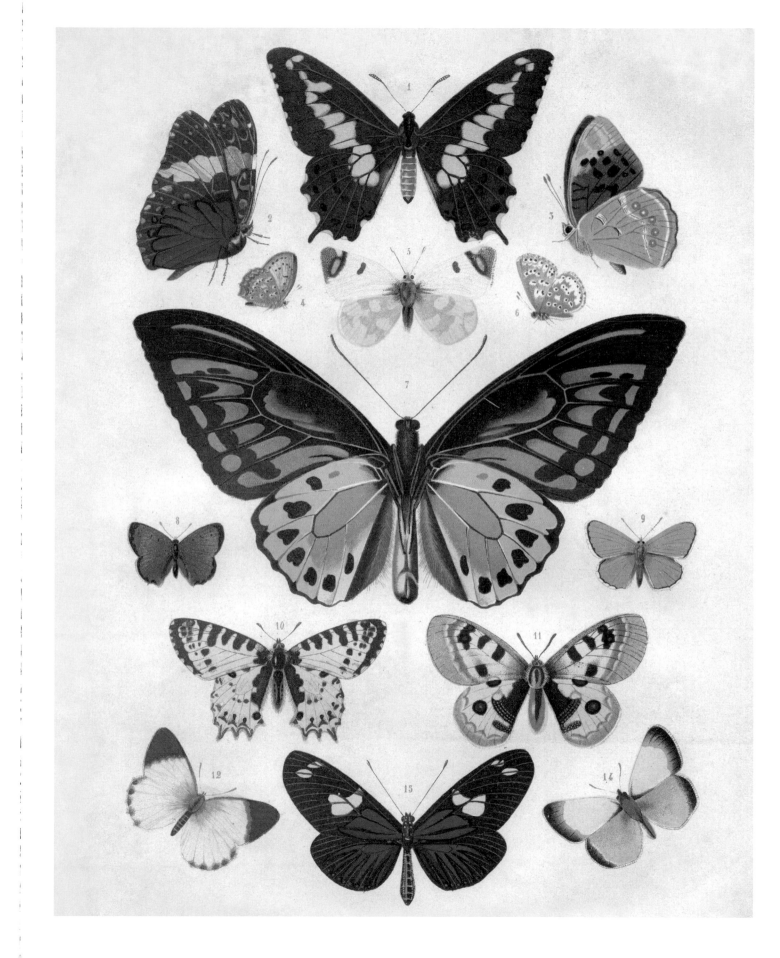

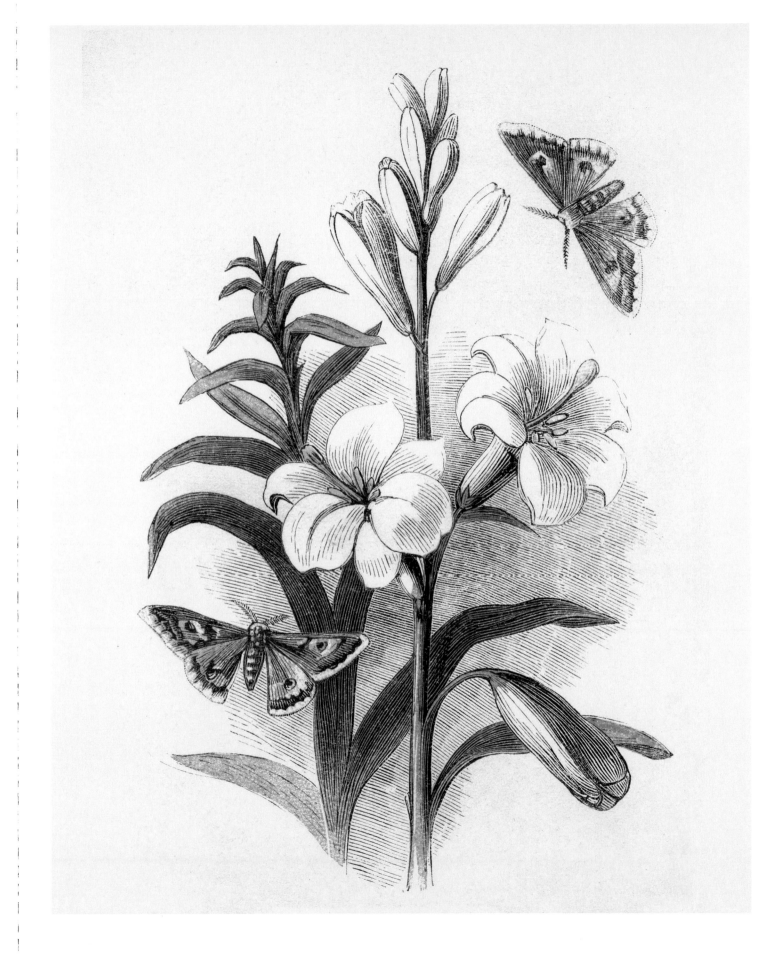

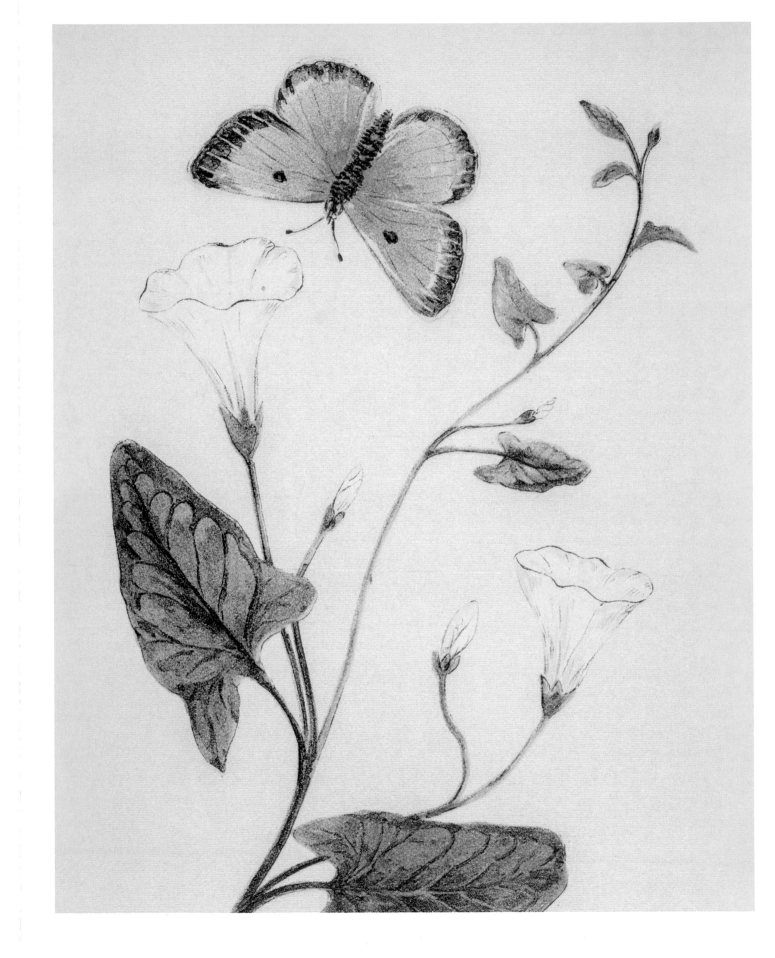

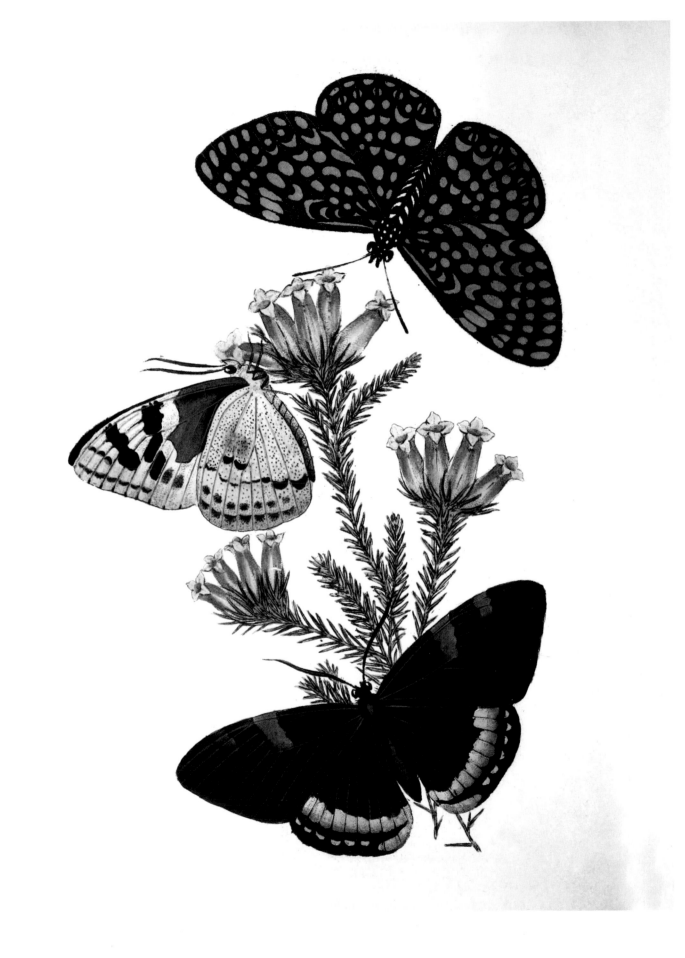

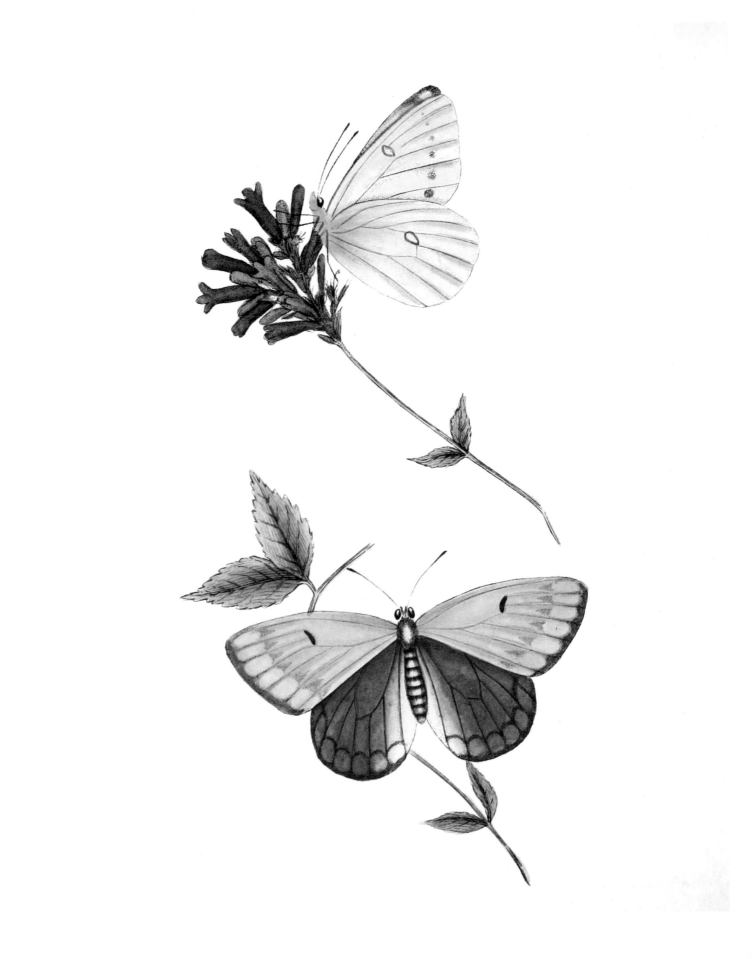

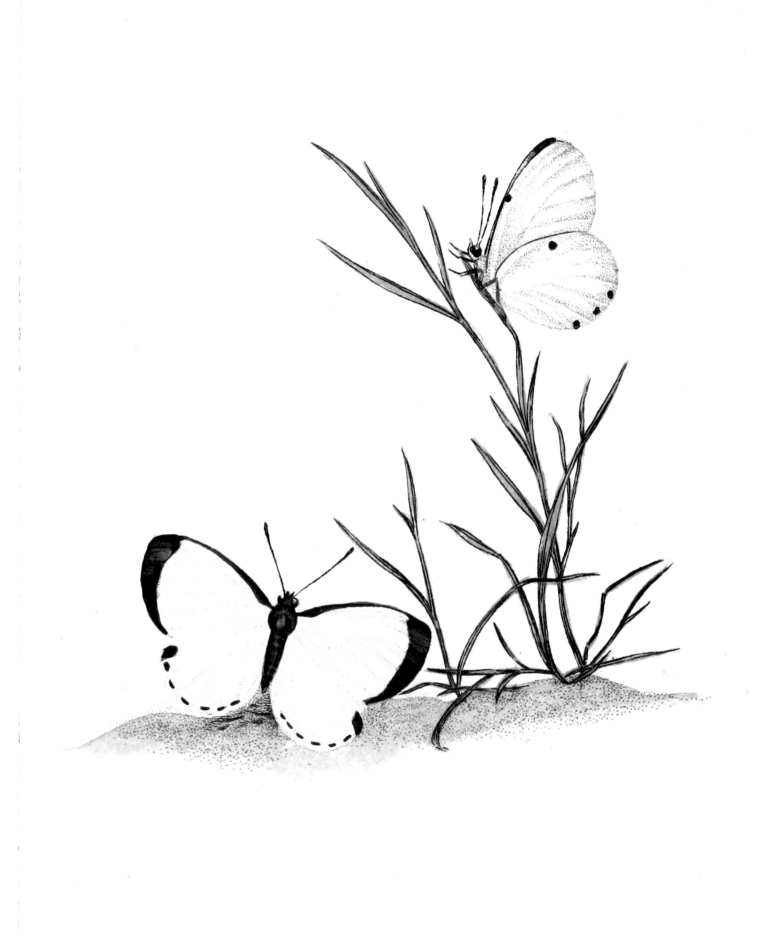

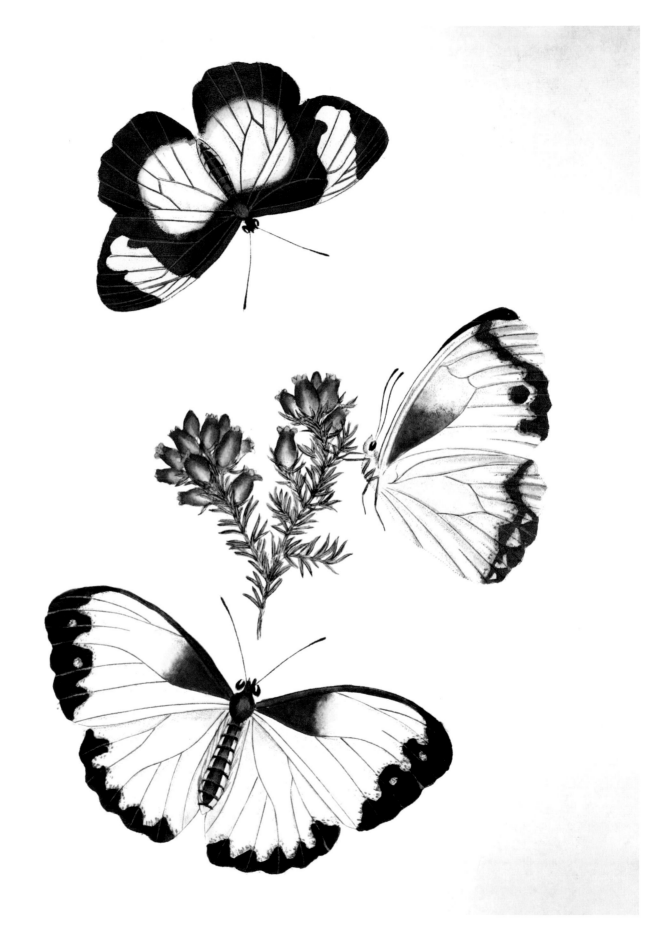

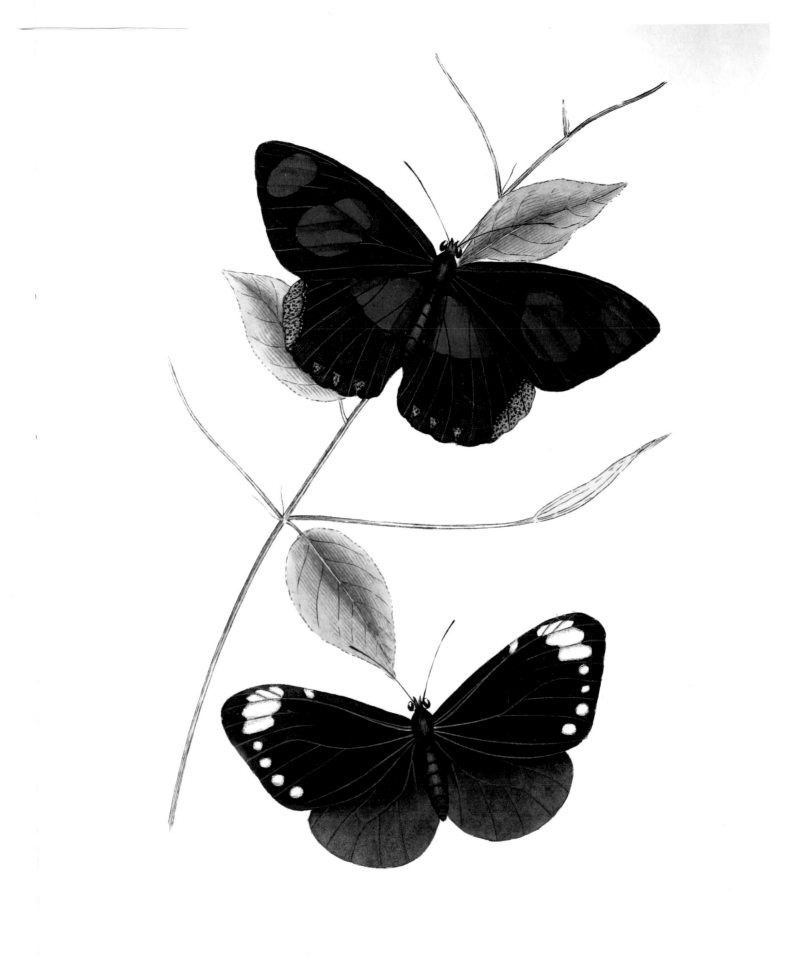

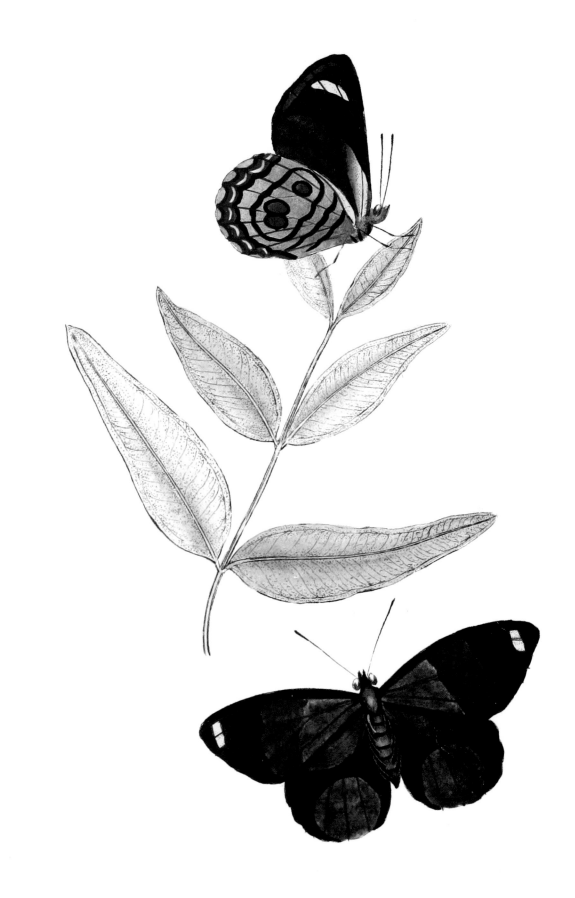

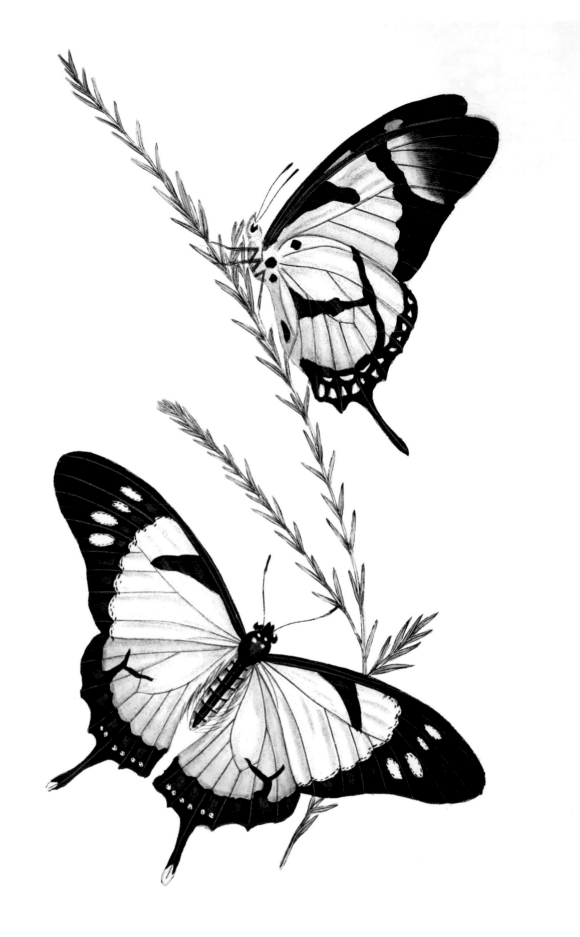

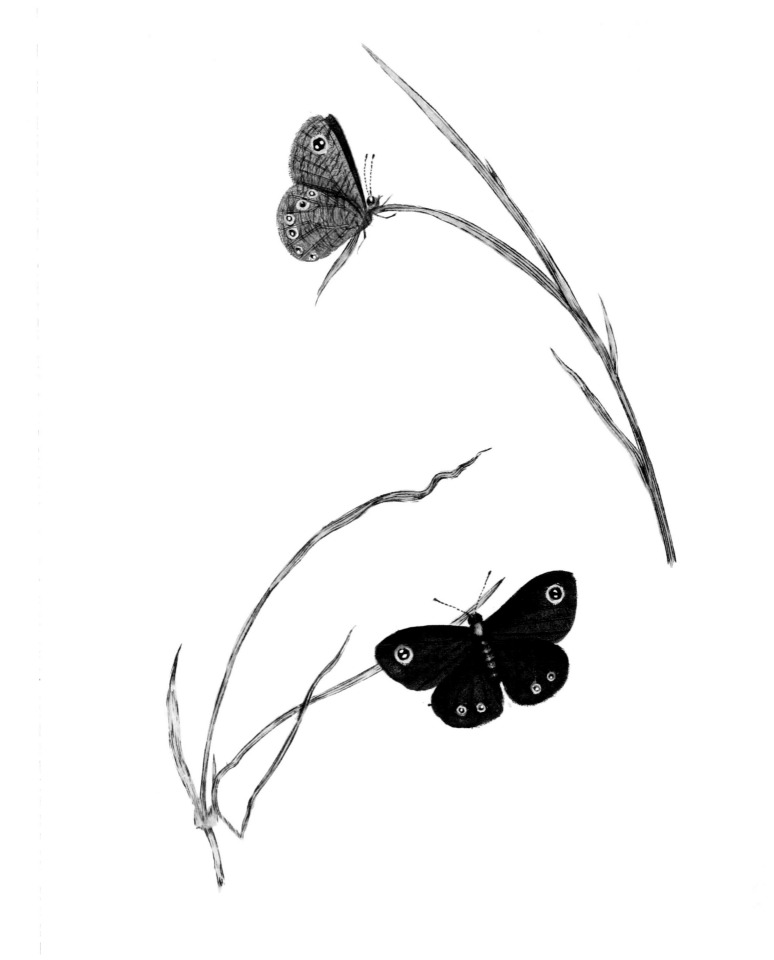

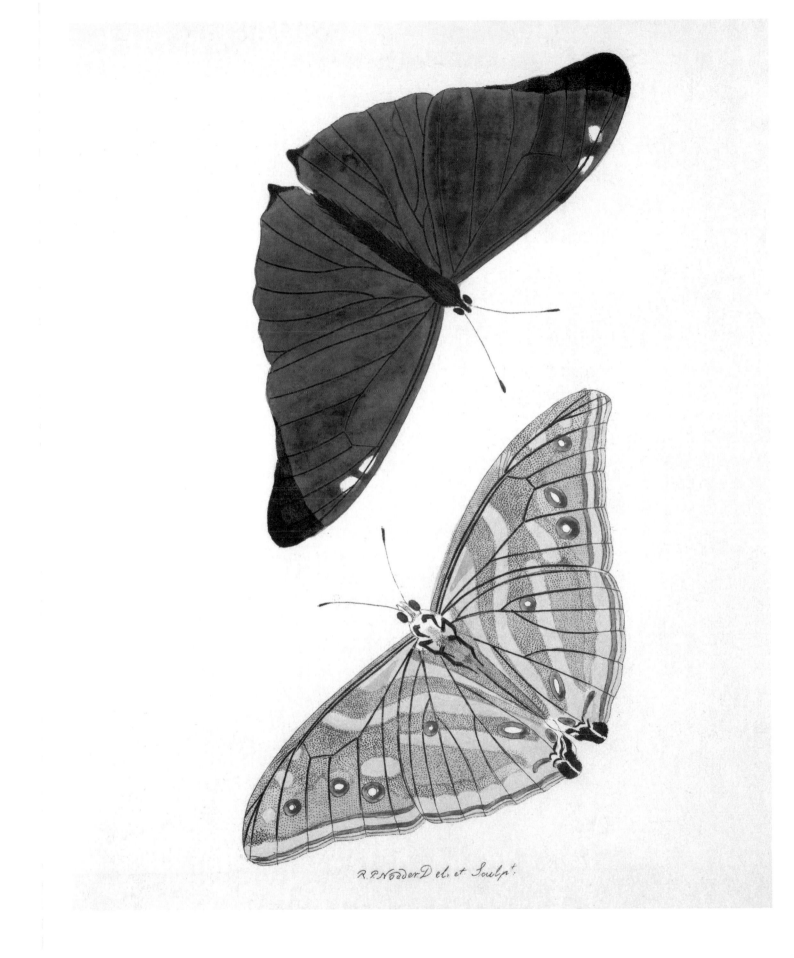

R.P. Nodder Del. et Sculp.t

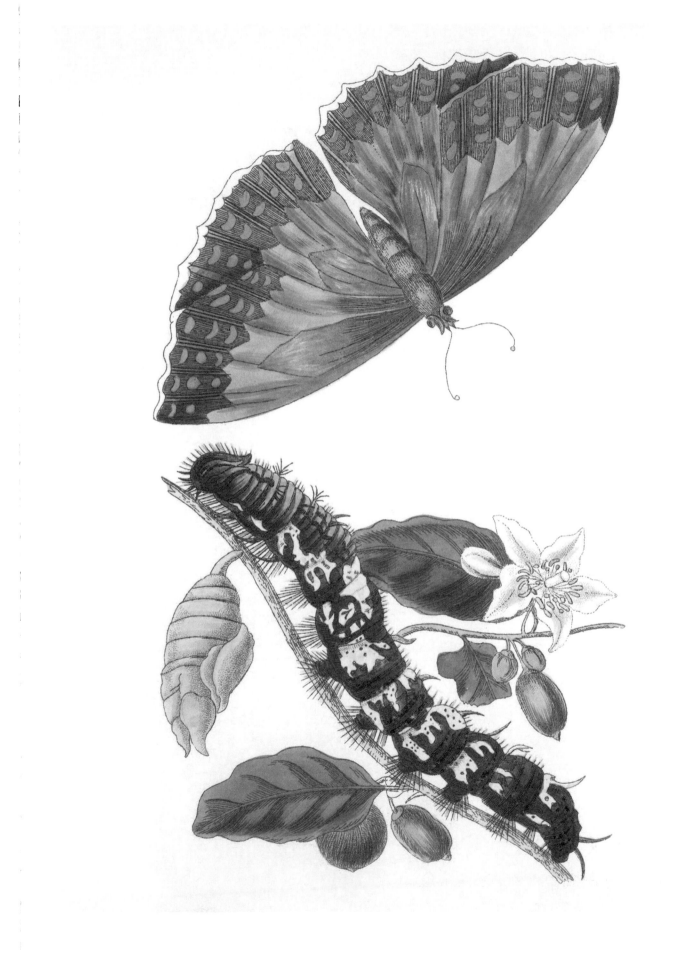

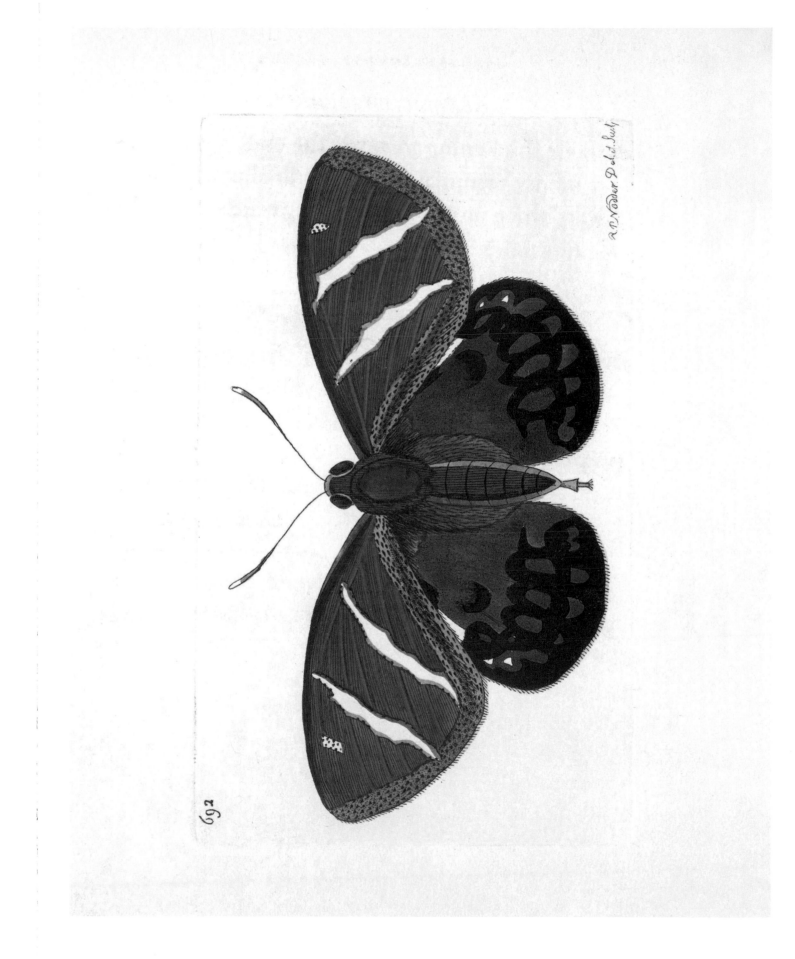

692

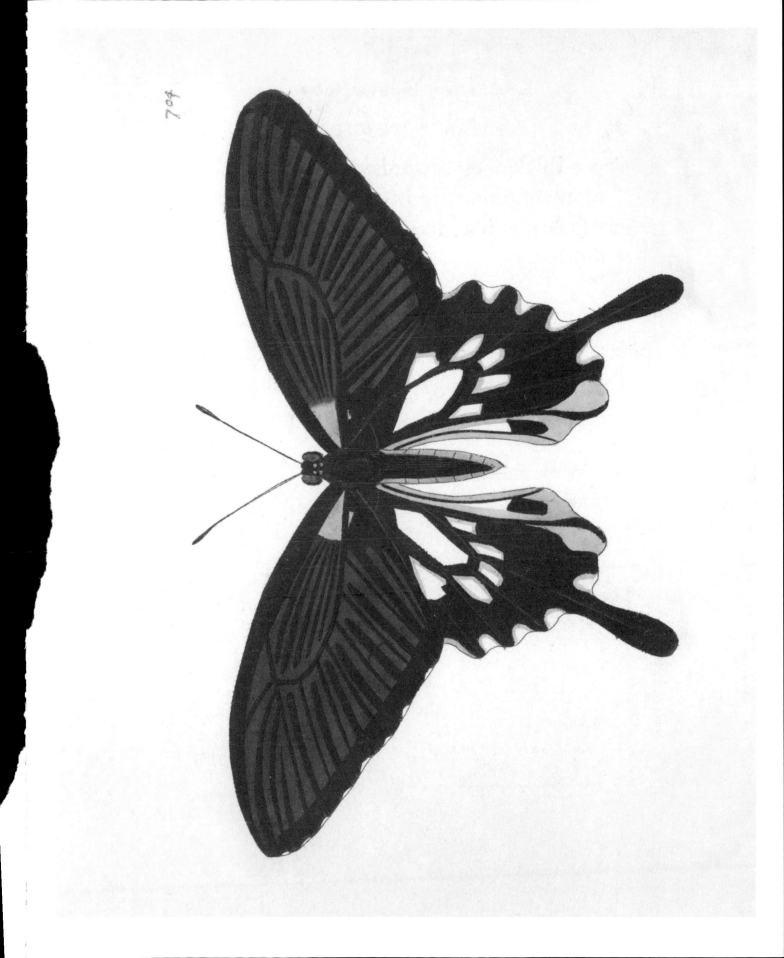